FRAGMENTS FROM THE DELTA OF VENUS

Art and Introduction by Judy Chicago

Text Selections from Anaïs Nin

 powerHouse Books
New York, NY

Acknowledgements

First and foremost, I wish to acknowledge Anaïs Nin, who inspired me to begin writing many years ago and whose grace and courage continue to inspire me today. Thanks also to Rupert Pole and The Anaïs Nin Trust for preserving Anaïs' legacy, and for giving me permission to use her writings for this book.

I owe great appreciation to my loyal agent, Loretta Barrett, who has shepherded my books since her days as an editor at Doubleday, and now as an independent agent; her hard work and dedication have made my writing available to many generations of readers.

Thanks are also due to my former assistant, Jon Cournoyer, who helped me in countless ways while preparing both the manuscript and the photographs. A special thanks to my new assistant, Ann Skinner-Jones, whose help has become invaluable to me. And of course, without the help and support of my husband and gifted photographer, Donald Woodman, I would be bereft.

Lastly, allow me to thank the group of talented people who comprise powerHouse Books; both the literary public and I are fortunate that they are willing to continue a tradition of integrity and risk-taking too often lacking in publishing today.

Judy Chicago

Judy Chicago, born in Chicago in 1939, is an internationally renowned artist, author, and feminist whose career now spans four decades. Her art has been widely exhibited in the United States as well as in Canada, Europe, Asia, Australia, and New Zealand. In addition, she has also published seven books about her life and work, and coauthored *Women and Art: Contested Territory* (Watson-Guptill, 1999) with British art writer Edward Lucie-Smith. There have been innumerable scholarly publications devoted to Chicago's art by notable authors such as Dr. Amelia Jones, Lucy Lippard, Edward Lucie-Smith, and Arthur Danto.

Over the course of her artmaking career, Judy Chicago has created both individual series and a number of major collaborative projects. She has been particularly interested in exploring subject matter and techniques that have been marginalized or absent from the art historical record. Her subjects include women's history and sexuality, the birth experience, the Holocaust, and more recently her own life and relationships. Chicago's search for a visual language of female sexual agency and an equitable and mutual sexuality has been at the core of her erotic imagery for many years. The watercolor series and print suite "Fragments from the Delta of Venus," and the book of the same name that you now hold in your hands, is the culmination of these explorations.

Her most famous work, "The Dinner Party," has been seen by more than one million people in six countries during its sixteen exhibitions. It was recently acquired by the Brooklyn Museum of Art, where, in 2006, it will be the centerpiece of the Elizabeth A. Sackler Center for Feminist Art. Other major collaborative traveling exhibitions include the "Birth Project," the "Holocaust Project: From Darkness into Light," and "Resolutions: A Stitch in Time."

Chicago's work is included in countless museum and private collections; she is the recipient of four honorary doctorates and numerous awards and grants. In 1996, the Arthur and Elizabeth Schlesinger Library on the History of Women in America at the Radcliffe Institute at Harvard University became the repository of Chicago's papers. Art historian Gail Levin is writing a biography examining Chicago's life, to be published in 2006. Chicago lives in Belen, New Mexico, with her husband, photographer Donald Woodman, and their six beloved cats.

Anaïs Nin

Anaïs Nin was born in 1903 in Neuilly-sur-Seine, on the outskirts of Paris, the daughter of the Spanish composer Joaquin Nin and singer Rosa Culmell. At the age of eleven, Nin and her two brothers came to America with their mother, who had separated from their father. On that trip, she carried a small diary, which eventually grew into the celebrated volumes of *The Diary of Anaïs Nin*.

While living in New York City's Greenwich Village in the 1940s, unable to interest commercial publishers in her writing, Nin established her own press and printed her own books. As a result of this willful move, Nin was finally able to gain notice in New York literary circles when her book of stories, *Under a Glass Bell* (1944), was favorably reviewed by Edmund Wilson.

In early 1940, Henry Miller, Nin's friend and ex-lover, was approached by a collector of pornography who wanted Miller to write for him. The collector offered to pay a dollar a page, and Miller soon enlisted Anaïs Nin and a few other friends. The endeavor began as a joke, but Anaïs kept at it, finding she was able to inject her own inimitable style into these sexy stories. The stories have been collected into two books: *Delta of Venus* (Harcourt, 1977) and *Little Birds* (Harcourt, 1979).

In the 1950s Nin began to divide her time between New York and California. She eventually settled into a house in Los Angeles, where the function of her personal diaries changed forever when she published *The Diary of Anaïs Nin, Volume One: 1931–1934* in 1966 with Harcourt. Anaïs and Gunther Stuhlman, the editor of the *Diaries*, decided to begin the series in 1931 to coincide with two pivotal moments in Anaïs' life. It was in that year, while living in Paris, that Anaïs Nin wrote her first book, a highly subjective book of criticism entitled *D.H. Lawrence: An Unprofessional Study* (Edward W. Titus, 1932). In addition, Anaïs met the famed novelist Henry Miller in this year, beginning a relationship that would prove to be very influential on her personal life as well as her literary career. Nin's *Diary* was followed by six more volumes in her lifetime, then by the "Journal of Love" series, a four-volume collection of unexpurgated sections of her diaries from the years that comprised the original volumes, and four volumes of *The Early Diary of Anaïs Nin*, stretching from 1914 to 1931, published after her death. Anaïs Nin died of cancer in 1977.

Introduction

Is devotion to others a cover for the hungers and the needs of the self,
of which one is ashamed? I was always ashamed to take. So I gave.
It was not a virtue. It was a disguise.

——Anaïs Nin, from her unpublished diary, #63

History has not always been kind to Anaïs Nin. Within a year of her death, Cacharel produced a perfume called "Anaïs Anaïs," as if all that was left of Nin's life and work was the exotic aroma of a memory. And, sadly, many young people no longer even know her name—or her work. As a student of women's history, I know that erasure has been the lot of too many women of achievement. But what does it mean when the name of a woman writer is popularized not by literary recognition, but instead by the dubious honor of having a scent named after her?

And then there is the rage, which seemed to erupt soon after her death. For example, in speaking about the many young women (myself included) who were inspired by her, James Wolcott, writing in *The New York Review of Books* (June 26, 1980), characterized them (us) as "the cult," going on to belittle all who revered her by calling them "Ninophiles."

This fury seems to continue unabated among some of those who remember her today. One instance of this is Claudia Roth Pierpont's book, *Passionate Minds: Women Rewriting the World*, published in 2000. "Nin's celebrated *Diary*, eventually published in seven volumes...offered a widely appealing portrait of an independent woman in an artistic milieu." So far so good. But a few pages later the author gives us her appraisal of Nin's lifetime of work: "The real and bottomless subject of Nin's diary is not sex, or the flowering of womanhood, but deceit," an accusation arising from the fact that during her lifetime Anaïs Nin altered her diaries for publication, sometimes for legal reasons, other times to protect someone she loved. She did this also out of the very human and forgivable desire to present herself in as positive a light as she could, given the unconventional life she had lived.

If Pierpont vilified her for her manipulation of reality, she was even more vicious when Nin told the truth. In *Incest*, the posthumously published volume from the unexpurgated "Journal of Love" series, Nin divulged the facts of an affair she had

had with her own father, a revelation that prompted Pierpont to write: "In this instance, rewriting her history was probably Nin's best deed for the feminist cause, and her most important lie. For even in an age of hard-won and vulnerable freedoms, the truth we are offered now is recognizably obscene." Pierpont ends her essay with a cruel and patronizing assessment of Nin's autobiographical writing: "For the reader able to escape the solitary confinement of these endless pages through the mere act of closing a book—such simple deliverance—relief is dulled only by a shuddering pity for the woman who lived all her days trapped inside." Poor Anaïs, it seems as though she just couldn't win.

This harsh assessment seems so different from my own memories of Anaïs Nin, whom I first met in the summer of 1971 at a party in Los Angeles. When I met Anaïs, I had just returned to L.A. after a year's absence, during which I lived in Fresno and initiated a woman-centered art practice and art education that I would later call Feminist Art and Feminist Art Education. During that time, my students and I had put out an edition of a now-defunct, monthly feminist journal called *Everywoman*, for which I had written an article called "My Struggle as a Woman Artist." This short essay, which somehow Anaïs had read, described my ten-year fight to be taken seriously in the overly macho L.A. art scene of the sixties.

Although I cannot at all remember who hosted the party where I first met Anaïs, my initial glimpse of her was unforgettable. Tall, slender, and elegant, she spoke in a delicate voice with just a touch of an appealing accent that I could not identify. Softly, she told me that she had read my article and liked it, following this flattering statement with an invitation to visit her at her home in Silver Lake, a hilly and verdant part of Los Angeles.

I had read her *Diaries* and found them riveting, primarily because I had never before encountered such honesty in a woman's writing. How ironic that Anaïs should later be accused of lying. Perhaps it is because I straddle the generation between her's and the younger women like Pierpont, who are so critical of her, that—despite Nin's editing and re-editing of the *Diaries*—I was able to recognize her words as giving voice to the experiences of countless women, myself included.

My guess is that many young feminists cannot even begin to imagine what life was like for women when there was no information about women's history, no theories to explain gender relations, no permission to challenge sexist assumptions, and absolutely no possibility of telling men the truth about ourselves—or about our perceptions of them—as males were thought to be too fragile for such disclosures. To be truly honest with men was to risk committing the greatest of sins, by becoming the "castrating woman," undercutting the "precious male ego," which—according to the prevailing mythology—had to be coddled, protected, and nurtured at all times.

I had also sampled Nin's fiction, which I found difficult—except for *A Spy in the House of Love*. The main character, Sabrina, seemed to reflect many of my own conflicts. In fact, the novel dazzled me with its description of the heroine's quest for the kind of sexual freedom that men enjoyed: the freedom to couple, achieve physical release, then disconnect from the moment of love without a backward glance.

Like many women of my generation, I had been raised with the notion that only men needed to reach orgasm in sex. Women were thought to be satisfied by the emotional contact available in sexual intercourse. However, these ideas conflicted with my own experience. I felt an intense drive towards sexual fulfillment, but—like Nin herself—was caught in socially inculcated expectations that men's needs should take priority over my own. It was because of my own often-frustrating sexual experiences that I could so identify with her words: "At this moment she feels impelled by a force outside of herself to be the woman he demands, desires, and creates." Given this imperative, one can only admire her ability to come to the realizations that she did, reflected in the words quoted in the epigram: "I was always ashamed to take. So I gave. It was not a virtue. It was a disguise."

Even though Anaïs eventually recognized this about herself, due to social attitudes during her lifetime (1903–1977), it would have been unthinkable for her to have openly revealed the truth about her life, feelings, and desires in her *Diaries* when they were first published. The most she could do was to leave the entire body of her journals to be read and understood once she and those close to her were dead, and thus unable to be hurt by what are some deeply shocking revelations, such as bigamy and, of course, incest.

However, I am sure she never dreamed that a time would come when young female critics would be wholly unsympathetic to the bravery required for a woman of Nin's generation to make herself the center of her writings, then to reveal herself as nakedly as she did (albeit incompletely in the published *Diaries*), and finally to leave such an unvarnished record in her journals. What woman before her ever had such courage—the courage to live such a life, and also the courage to reveal it for all the world to see—even if she was not able to risk complete exposure during her lifetime?

Sadly, one of the tragedies of women's history is that the next generation of women repeatedly seems unable to honor the women before them. This was true of my own generation in relation to the first wave of feminists and it is true today, as young women are unable to respect the second wave of feminists who laid the ground-work for whatever modicum of post-feminist freedom presently exists. As for men like James Wolcott, their incomprehension of the crucial importance of female role models contributes to the climate of dishonor, marginalization, or erasure that often besets even the greatest of women as soon as they die.

Am I suggesting that Anaïs Nin was a great writer? Not really, mainly because I do not know. I am not a literary critic, and for me to attempt a definitive evaluation of her work would be presumptuous. What I am suggesting is that Anaïs' legacy and her writing are of greater significance than is presently conceded, primarily because in her *Diaries*, she left us a record of a woman who struggled against the constraints of the "female condition," as it used to be called—or the "construct of femininity" as it is now labeled—and she accomplished this all by herself. For such an achievement, in my opinion, she is to be not only admired, but also revered.

And I revered her, from the first moment we met. So much, in fact, that when I paid her a visit on that first warm day in the late summer of 1971, I found it hard to imagine myself accepting any service from her hands, be it the preparation of food or even the squeezing of oranges for a glass of juice. Later in the year I reflected in my journal:

> [About] my visit with Anaïs...ostensibly for lunch, but she wasn't eating and the idea of her cooking for me was beyond me. She squeezed me some juice, and as I watched this [sixty-eight-year-old] woman, I looked at her slender hands and thought about how they had written so many wonderful words. I was very moved. We got along wonderfully and...she walked me all the way to my car and we kissed.

At the time I first met Anaïs, I was trying to sort through a confusing period in my life. My first decade of professional art practice took place before the second wave of feminism, which began in the late sixties. When the early literature appeared from what was then called women's liberation, I read it with a sensation akin to what a drowning woman might feel upon being rescued just short of submersion. These writers were describing my own experiences as I struggled to establish myself as a professional artist.

From the time I was young, I had my sights set upon becoming an artist, one whose work would end up in the art history books. I never thought my gender at all relevant to my ambition—until I reached graduate school and ran smack into what used to be called male chauvinism, an attitude that was manifested in the art world by the commonplace exclusion of women from most major museum collections and exhibitions, and the oft-repeated assumption that there had never been any great women artists (with the implication that there never could be any). And if one attempted to complain about the art community's blatant sexism, one was disparagingly called "some kind of suffragette."

In fact, the space between a "suffragette" and a "castrating bitch" was extremely narrow, to say the least, and many women of my generation fell between the cracks that appeared whenever one attempted to traverse such an unpropitious path. I was one of the lucky ones—I at least became accepted as an artist in the Los Angeles art community. But the price was high indeed. Under no circumstances could my art reveal my gender and I felt compelled to act like "one of the boys" in order to achieve even a semblance of validation.

Although I went along with this, underneath I seethed. When the women's liberation movement began, I joyously realized that I was not the only American woman who was fed up. I had a lot of company. It was as if a door had suddenly opened and the light streamed in. What I saw was the chance to be myself as a woman artist, something that until then was a complete impossibility in an art scene where the most prominent male critics thought nothing of announcing that one could not be a woman and an artist at the same time.

But how to fuse these realms? That was the question. For ten years I had been learning how to censor every feminine impulse, not only in my art, but in my persona as well. I had taken a decidedly different path than had Anaïs Nin. Whereas she had taken on the role of the "eternal feminine," I had rejected everything about any behavior that smacked of femininity. This dilemma is what I had gone to Fresno to resolve, and it was this that I discussed with Anaïs the first time I visited her. In a rush—no, a torrent—of words I told her everything I was thinking about and grappling with. It was such a relief to talk to her. In all of my life, I had never had a woman mentor, and I was more grateful to Anaïs than I ever had the chance to tell her.

According to the seventh volume of Anaïs' published *Diaries*, our first meeting impressed her as well:

> Our first meeting was very interesting. I was intimidated by [Judy's] powerful personality. She was intimidated by the lady of the *Diaries*....
> But what happened is that we immediately felt tenderness and recognized that we needed each other.

In addition to the sense of mutual recognition that took place between us, Anaïs suggested that I should write a book, which shocked me, in part because at that time artists were expected to be seen but not heard. The mystique of the mute but heroic abstract expressionist was still strong, and the role of the artist was certainly not thought to include writing—at least that was my impression.

Although intimidated at first, I did indeed follow Anaïs' advice—advice which included the assurance that I could in fact write. More importantly, with her help I came to the realization that writing might allow me to think my way through the new choices available to women, to work out ideas that seemed all a muddle of confusion. And thus I began my literary journey, one which to date has produced eight books by my own hand, along with one coauthored volume, with more books planned. All this I owe to Anaïs, for I doubt that I would have seriously taken up writing without her encouragement.

Anaïs wrote the introduction to my first book, *Through the Flower: My Struggle as a Woman Artist*, a publication that grew out of the early essay that she had read and out of the many discussions we had during the three years in which I visited her regularly. During that time, our conversations focused mainly on ideas about a female-centered art, something about which we both felt strongly. To acknowledge the influence that my discussions with Anaïs had on me, I began *Through the Flower* with a quote from her *Diaries*:

> ...Woman's creation, far from being like Man's, must be exactly like her creation of children; that is, it must come out of her own blood, englobed by her womb, nourished with her own milk. It must be a human creation, of flesh, it must be different from Man's abstractions.

Even though my views have changed somewhat over time, becoming less essentialist, Anaïs' words proved inspirational in that they affirmed my growing conviction that women artists might have something entirely different to say—not because of some innate biological differences from men, but rather because there are many ways in which our socialization and experiences differ.

In addition to our private visits, we were also involved in a number of public activities together, including an event organized in Anaïs' honor in Berkeley and a panel on education in Los Angeles. The Berkeley celebration produced at least three different written versions of what took place. Both Anaïs and I recorded our own impressions in our journals, but the historian Ruth Rosen presented quite a different picture from either of ours in her recent book, *The World Split Open*:

> Imagine, if you can, a Sunday-morning brunch held in the living room of a modest home in Berkeley....The featured guests are Judy Chicago...and Anaïs Nin....Chicago proudly shows her recent work, a print of a woman pulling a used Tampax out of her vagina. Nin is appalled...she recoils from what she describes as "vulgar art." Soon they retreat to the kitchen, shouting and arguing....

My own memory is quite different, although it is true that Anaïs and I disagreed. While my childhood was full of raucous and high-volume intellectual discourse that had predisposed me to shouting, I cannot remember Anaïs ever raising her voice. Whatever differences we might have had were always discussed quite amiably. For instance, the topic of women's art came up again when Anaïs and I did a 1972 radio show on KPFK in Los Angeles. In our debate, we discussed the idea of women openly expressing the physical aspects of female reality through art—realities such as menstruation. I don't really think that Anaïs was "appalled" by "Red Flag" (my menstruation image), though she did argue that women's emphasis should be on feeling, while I countered with the argument that we must make our hidden emotions and experiences visible and acceptable. After the radio show, she called me to say that I was her "radical daughter" and that she loved me, a feeling that I reciprocated.

I believe that Anaïs was far less upset about our disagreements—or for that matter, my art—than she was about the criticism that was sometimes leveled against her by radical feminists. In a letter she wrote me that was subsequently published in *The Diary of Anaïs Nin, Volume Seven: 1966–1974*, she complained: "I suffered twenty years of criticism for being apolitical....The *Diaries* show I found another route to liberation....I inspire women. I do not propagandize....Do you think that if I held out against men's political obsessions for thirty years and accepted persecution from them, I will yield now to women's imitation of revolutionary tactics?"

Sometime later, she invited me to participate in a panel discussion with Lawrence Durrell, Buckminster Fuller, and herself, organized to publicize the opening of the International College, an alternative school without walls. Both Anaïs and I were on time, but the two other panelists were late. The audience milled around for what

seemed like ages until Durrell appeared, almost an hour late. The session was in full swing when Bucky Fuller finally strode in, positioning himself in front of the table where the three of us were sitting, rudely interrupting what had been a polite though lively discussion. Ignoring everyone else on the panel, Fuller selfishly took over the session, walking back and forth in front of us and ranting on about all that he had done and when he had done it.

I became furious, in part because of my memories of domineering male professors in college, but more because I was outraged at the insult he was paying to Anaïs, not to mention the rest of the panel. Somewhat timorously, I raised my hand and asked whether it was possible for anyone else to speak. At first, Fuller didn't hear me or if he did, chose not to acknowledge my question, which I repeated. Finally, he turned around, and in a voice shaking with the terror I felt in challenging such a figure of authority, I made as impassioned a statement as I could muster about his insensitive behavior and my belief that education involved a level of shared communication that his conduct entirely precluded.

The response was pure silence—and shock. When the audience began to realize what I had done, they turned on me, none more vociferous in their reaction than some of the women, probably because they could not believe my audacity in challenging so august a personage as Buckminster Fuller. From the look on Durrell's face, I believe that he found my outburst entertaining. Just when I thought the audience was going to rise up and collectively storm the stage and pillory me, Anaïs stood up, and in her gentle and elegant voice suggested to the audience that they had just witnessed a classic confrontation between the masculine—rational, logical, and objective—and the feminine—intuitive, emotional, and subjective—and followed this insight by suggesting that it was the purpose of education to unite these differing approaches. Then she sat down.

Her words seemed to defuse what was an extremely tense situation, and I breathed a sigh of relief. Later that evening, Anaïs called me to express concern about whether I considered her comments a "cop-out." "Not at all," I replied. On the contrary, she had saved my life. I tell this story not only because I consider it amusing, but more importantly, because it conveys something of Anaïs' astonishing grace, any awareness of which seems singularly lacking in most of the books and articles I have read about her over the years. In fact, given her incredible personal charm and generosity of spirit, I find it astounding that she has elicited such anger from critics.

The last story I wish to tell about Anaïs further emphasizes her graciousness. In 1974, when she was already ill from the cancer that would claim her life—although I did not know about it then—I again visited her in L.A. I had just returned from an exceedingly difficult few weeks spent in Bellingham, Washington, where I had gone to work on a new series of drawings and to spend time with my (then) husband, who was working on a sculpture at Western Washington University. The trip had been a success in relation to my art, as it was there that I began to formulate the designs for what would be the first of the china-painted plates in "The Dinner Party" (my monumental tribute to women in Western civilization).

Not so successful was the time spent with my husband, who had used the occasion to reveal that, over the course of our ten-year relationship, he had engaged in a series of affairs with his students. Although I was devastated by this confession, it would be some time before I ended my marriage, something I should have done on the spot. Instead, as I have done throughout my career, even in the face of extreme anguish, I worked, producing the drawings I had gone there to create. While in Bellingham, I had experienced many perplexing and troubling feelings that I wanted to discuss with Anaïs. When I finally did see her, although still quite upset about my husband's revelations, I did not mention my personal difficulties. Instead, I described the panic that had overtaken me as I configured the imagery in the new drawings, a terrifying sensation, which I described to Anaïs as akin to a cancer growing in my womb.

Even now, I cannot write those words without feeling a sense of horror at my gall in saying this to her. In my defense, I have to repeat that I did not know that she had cancer, and to her enormous credit she never mentioned it. Instead, she reassured me, saying that what I was suffering from was fear of my own power, which I was experiencing as negative, even monstrous.

Earlier I discussed some of the societal attitudes towards female power with which I was raised, notably that if one's power were openly expressed, it would cause grievous harm to men. That afternoon in 1974, Anaïs helped me to understand that I had absorbed these attitudes, and that—as I began to more fully express my creative power—I had become frightened because I was confronting deeply internalized taboos. To this day, I feel enormously grateful to her for her wisdom and support, because she helped me find the courage to break through my fears.

I also feel extremely angry with those who attempt to besmirch her reputation and diminish her worth, as they seem to have no idea how profoundly women have been mutilated by some of the warped ideas that have been accepted—and foisted upon us—as truths. Nor do they seem to realize what strength it requires to stand up to society's mistaken notions about women and to claim the right to one's freedom, to one's personal expression, and, most of all, to live as a human being rather than some type of fictive, politically correct character. To Anaïs, who had the nerve to claim her humanity, with all of its flaws, and to leave us a picture of the woman she was, not the woman she was supposed to be, I say BRAVO.

Moreover, in addition to leaving us a record in her *Diaries* of her struggle out of the construct of femininity towards a more authentic existence, she also helped pave the way for women's sexual freedom, and for a literature that would express this new-found freedom. Recently, I went back and reviewed some of Anaïs' writing, and for the first time read *Delta of Venus*. Over the years, I have been exceedingly interested in the subject of female desire, a subject that is generally absent from the art historical record, at least from a woman's perspective.

I am not at all sure that when Anaïs originally sat down to pen erotica for one dollar a page she was focused on articulating a feminine perspective on sex. Years later, in a postscript to *Delta of Venus*, she wrote that at the time she was writing

erotica, "we had only one model for this literary genre—the writing of men…[but] I had a feeling that Pandora's box contained the mysteries of woman's sensuality, so different from man's and for which man's language was inadequate."

She went on to express her concern that because her early literary style was derived from the reading of men's works, she "had compromised her feminine self." However, rereading her erotic writing in preparation for its publication, she had come to see that she "was intuitively using a woman's language, seeing sexual experience from a woman's point of view." Of course, the postmodern feminist critique of the notion of a universal female point of view makes it difficult to claim that Anaïs spoke for anyone but herself. Still, this is achievement enough, particularly because even now there are not enough women's voices expressing the myriad aspects of female desire in either literature or art.

Although I did not like all of Anaïs' erotic writing, I found fragments quite riveting. And even though I was somewhat anxious about further eroticizing her reputation, I wanted to pluck those fragments from the slightly contrived stories in which they exist in *Delta of Venus* and try to create visual analogs to what I thought were extremely evocative phrases.

One reason that I wished to embark upon this project has already been stated—there are not enough images of female desire by women artists. Some time ago, I became acutely aware of this problem during preparation for a series of images that I based on a new translation of the Song of Songs, one that stresses the mutuality of desire. At that time I looked back through the history of art to find a record of erotic imagery dominated almost exclusively by men's viewpoints. As my career has been largely focused on areas of absence in visual iconography (women's history, birth, the construct of masculinity, etc.), addressing the absence of images of female desire was and still is important to me. Despite the many limitations of *Delta of Venus*, it remains significant because Anaïs began to break the silence about women's sexuality, as seen from one woman's perspective.

Too many aspects of female experience (or experiences, as the postmodernists would have it) remain partially or entirely unrepresented in art. As a result, women have an insufficient cultural repository of images that support and/or expand our own lived female experiences. This is particularly limiting to our sexuality, which has been used and misused by advertisers, pornographers, and male artists alike. Speaking metaphorically, until all the naked ladies painted by men on canvas or carved by them in marble, bronze, and stone rise up in the museums that house them, spread their respective vaginal lips, and insist upon the agency and potency of female desire, women's sexuality will continue to be enjoyed by everyone but women.

In closing, let me say that I hope that Anaïs would have liked my images as much as I like and admire her writing, her courage, and, most of all, her incredible generosity of spirit.

Judy Chicago
Belen, New Mexico, 2003

The Hungarian Adventurer

Her sex was like a giant hothouse flower...
and the hair around it abundant and curled, glossy black.
It was these lips that she rouged as if they were a mouth,
very elaborately so that they became like blood-red camellias,
opened by force, showing the closed interior, a paler,
fine-skinned core of the flower.

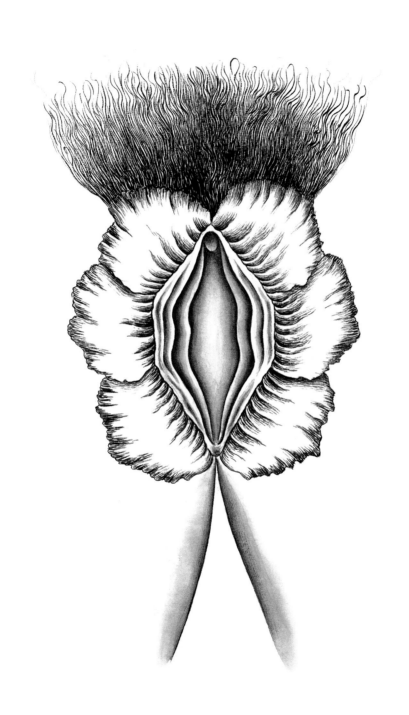

Mathilde

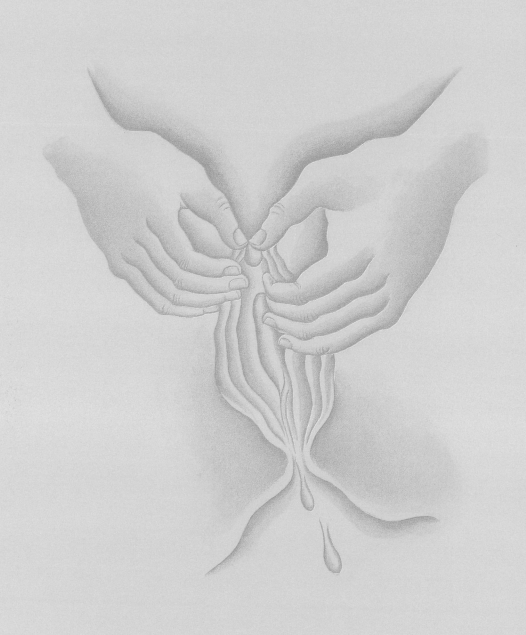

With her fingers she opened the two little
lips of the vulva...with the other free hand she
continued the caresses....From somewhere a salty
liquid was coming, covering the wings of
her sex; between these it now shone....

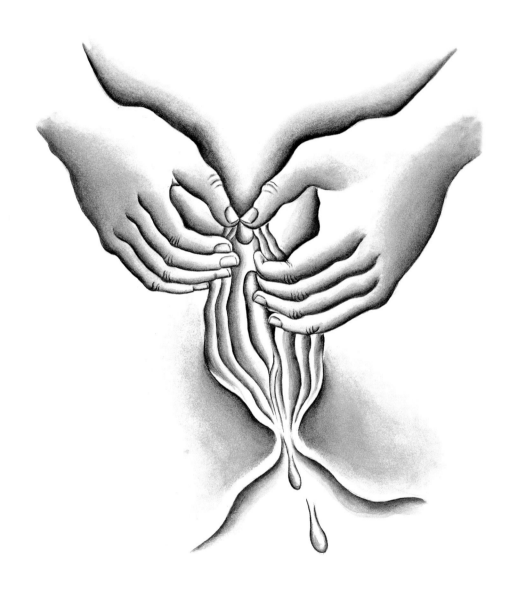

The Veiled Woman

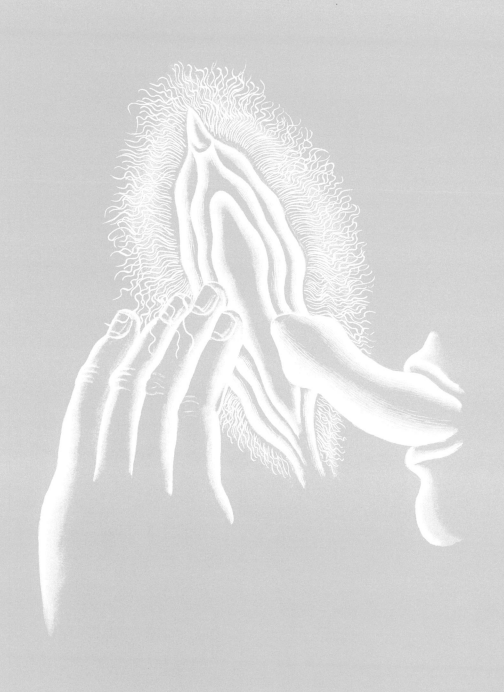

He parted the opening of her sex with his two
fingers, he feasted his eyes on the glowing skin, the
delicate flow of honey, the hair curling around his fingers.
His mouth grew more and more avid....As he bit into
her flesh with such a delicious sensation, he felt in her a
quiver of pleasure....And now their two mouths melted
into each other, seeking the leaping tongue.

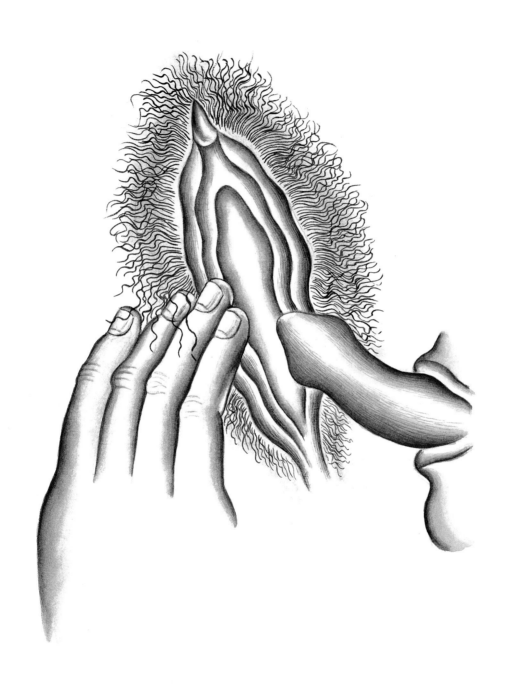

Marianne

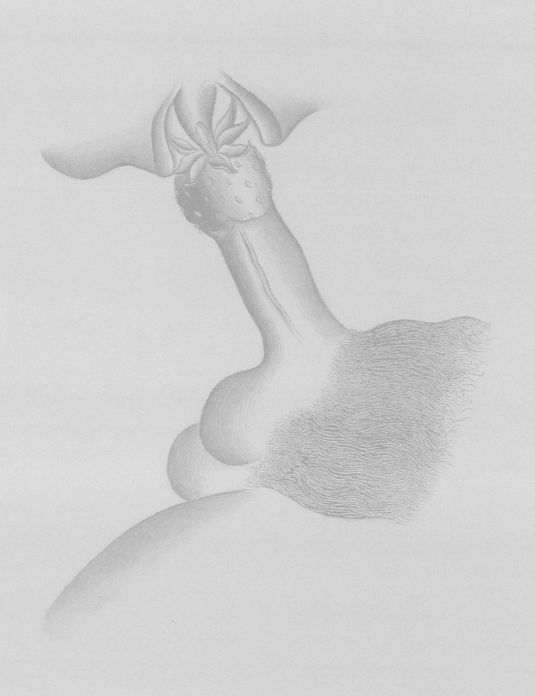

...she came closer, her lips parted slightly, and delicately, very delicately, she touched the tip of his sex with her tongue... she kissed it, enclosing it in her lips like some marvelous fruit, and he trembled. Then...a tiny drop of a milky-white salty substance dissolved in her mouth, the precursor of desire....

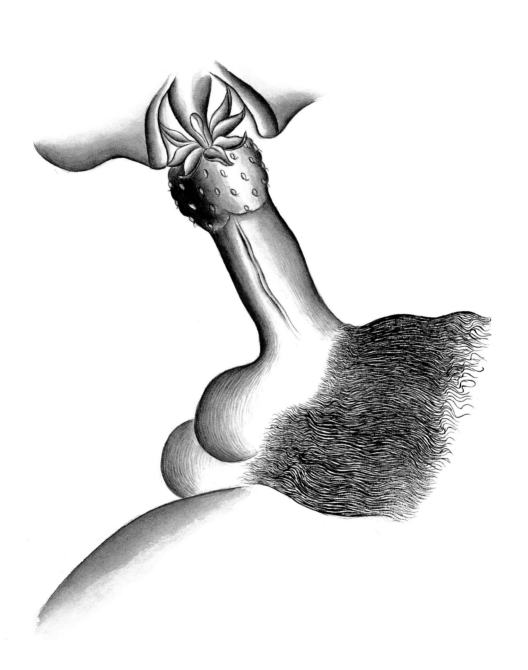

Mathilde

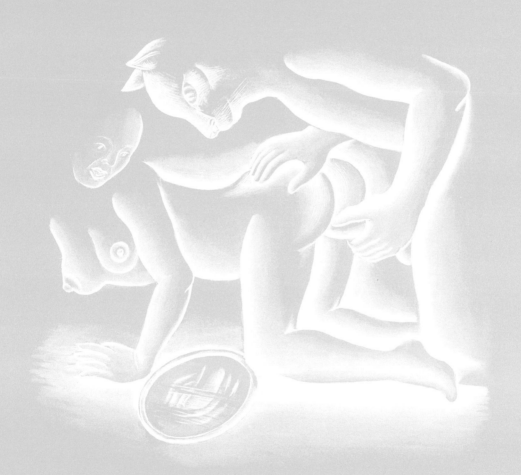

She was on her hands and knees looking
between her legs at the mirror....He crouched over
her like a giant cat, and his penis went into her....
He raised her ass with his two hands and fell on her....
The others found them still entangled on the rug.

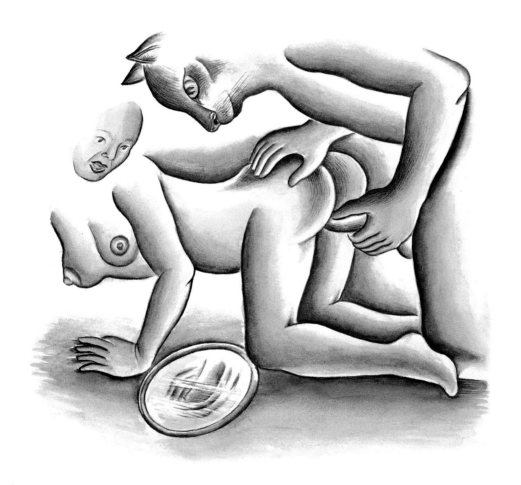

Artists & Models

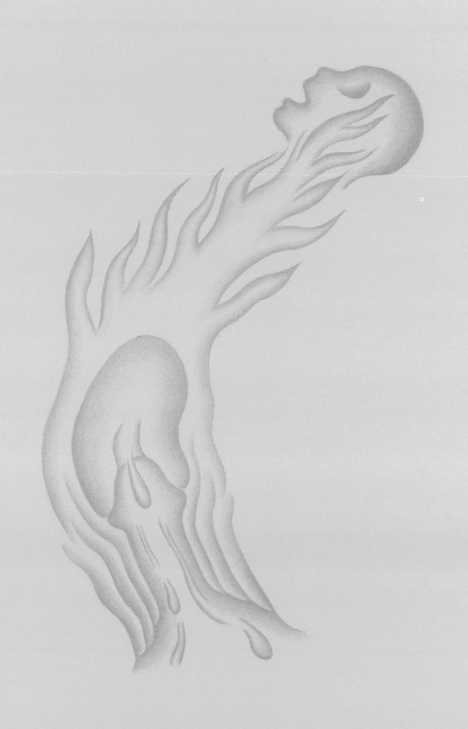

Her sexual hunger was rising like madness to her head, blinding her....The honey was pouring from her. As he pushed, his penis made little sucking sounds. All the air was drawn from the womb...and he swung in and out of the honey endlessly, touching the tip of the womb....

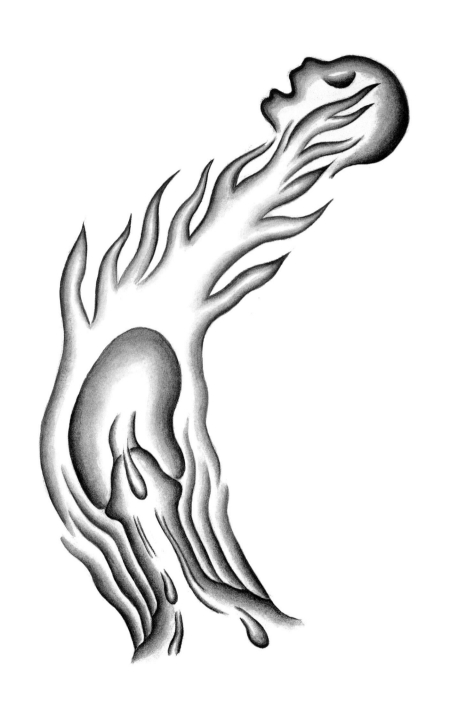

Lilith

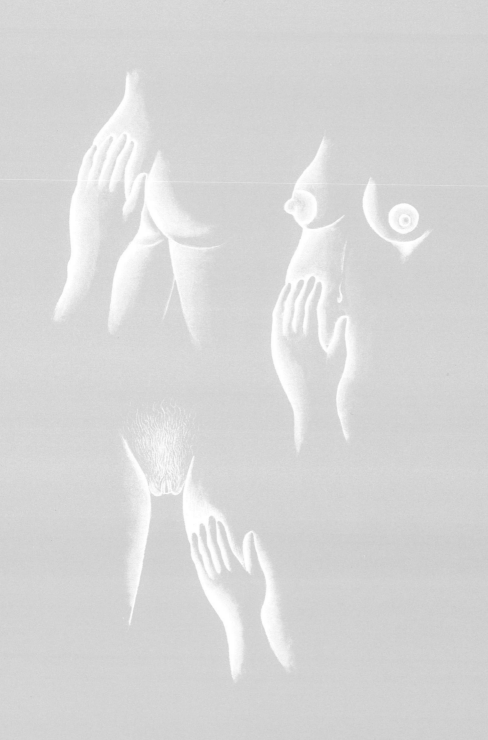

She had never caressed a woman....She had
sometimes thought to herself how marvelous it must be
to caress a woman, the roundness of the ass, the softness of
the belly, that particularly soft skin between the legs, and she
had tried caressing herself in her bed in the dark, just to
imagine how it must feel to touch a woman.

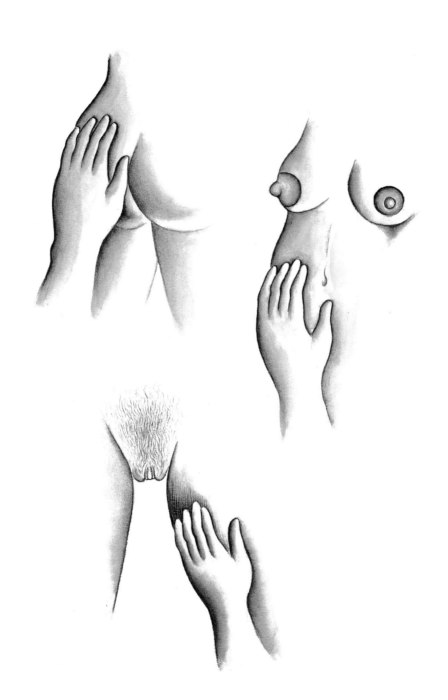

Artists & Models

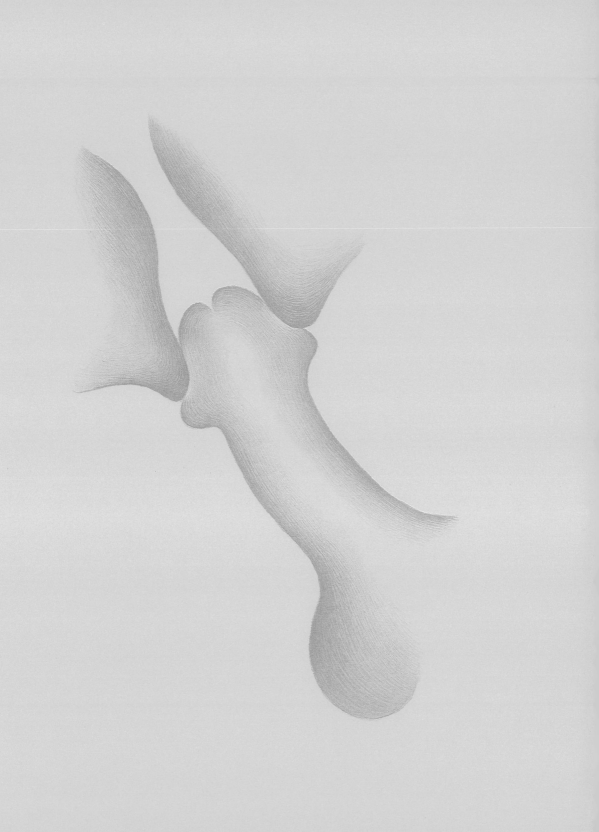

Sometimes she raised herself a little so that she
kept only the head of the penis in her sex, and she
moved lightly, very lightly, just enough to keep it inside,
touching the edges of her sex, which were red and swollen,
and she clasped the penis like a mouth. Then suddenly
moving downwards, engulfing the whole penis, and
gasping with joy, she would fall over his body....

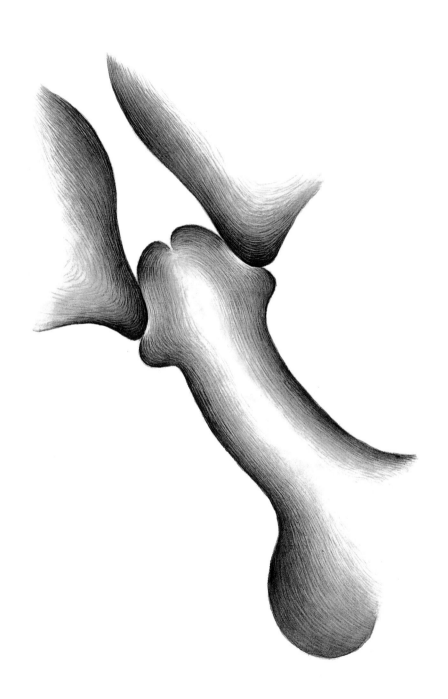

The Basque & Bijou

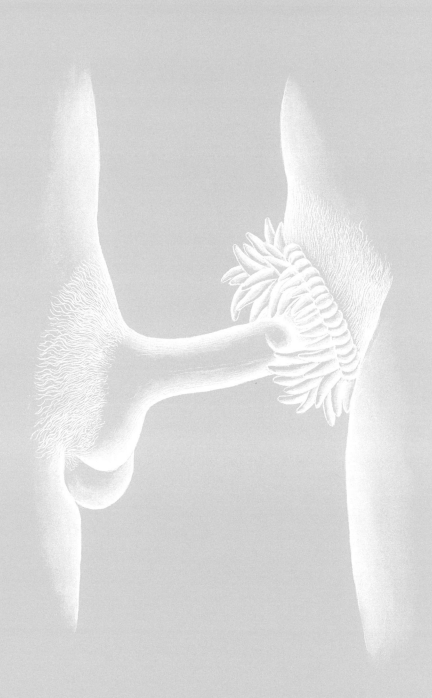

"Slip it in again," she begged....At the back of the womb there lay flesh that demanded to be penetrated. It curved inwards, opened to suck. The flesh walls moved like sea anemones, seeking by suction to draw his sex in....

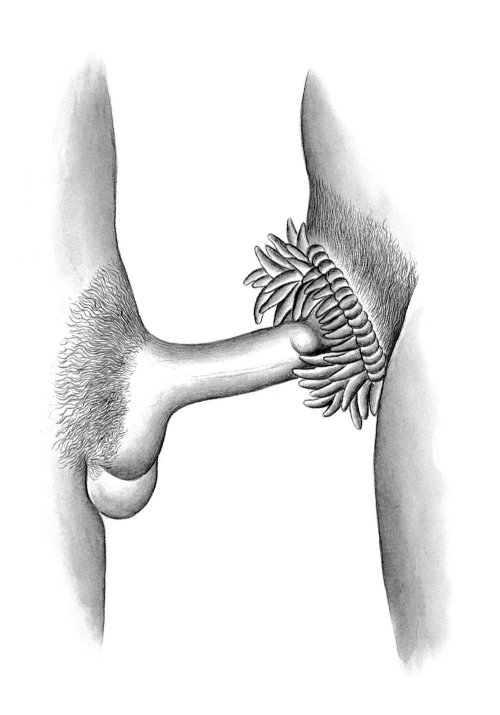

Elena

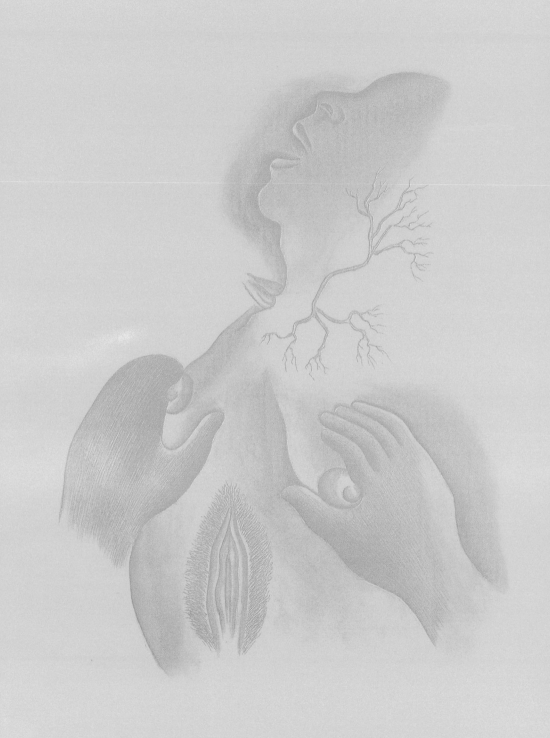

Then he kissed her, his two hands on her
breasts....He kissed her neck where the veins were
palpitating, and her throat, his hands around her neck
as if he would separate her head from the rest of her
body....His caresses had a strange quality, at times soft
and melting and at other times fierce....There was
something animallike about his hands....

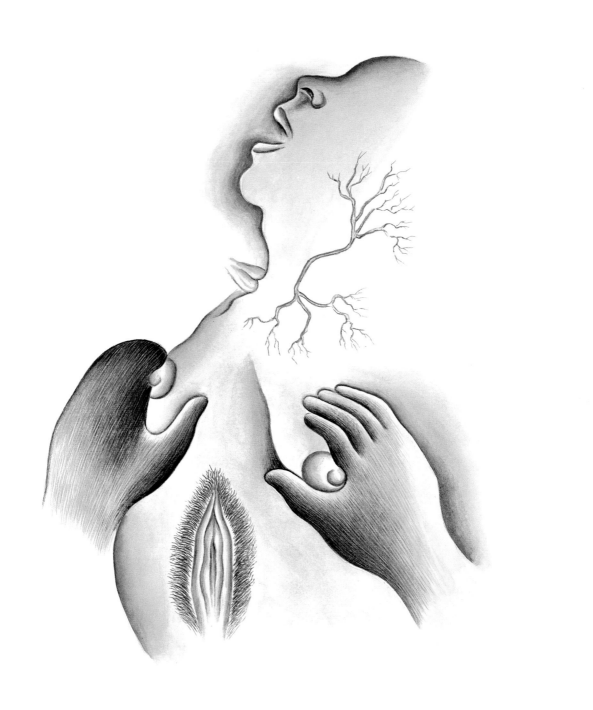

Lilith

...he will unbutton my blouse very slowly,
and I will feel his hands unbuttoning each button
and touching my breasts little by little, until they come
out of the blouse, and then he will love them and suckle
at the nipples like a child, hurting me a little with his teeth,
and I will feel all this creeping over my whole body,
untying each little tight nerve and dissolving me.

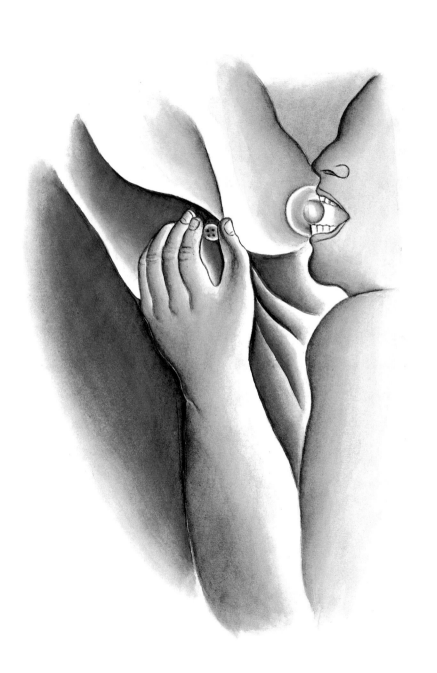

The Basque & Bijou

He imagined himself taking the panties off her body. The feeling was so vivid that he had an erection. He began to touch himself as he continued to kiss the panties....It seemed to him that he was touching her flesh....Suddenly he had an ejaculation....

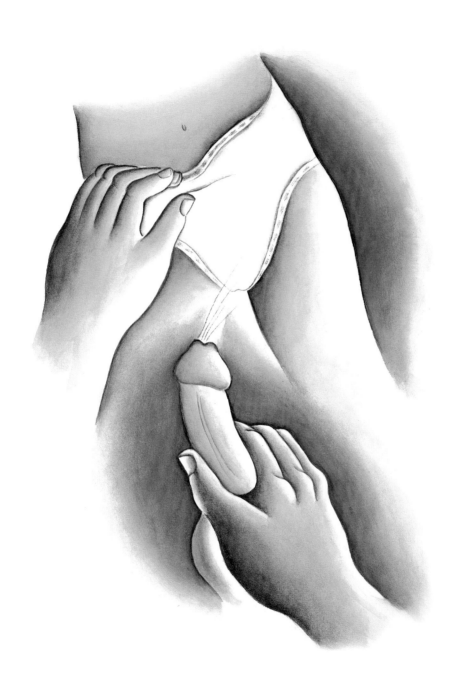

Pierre

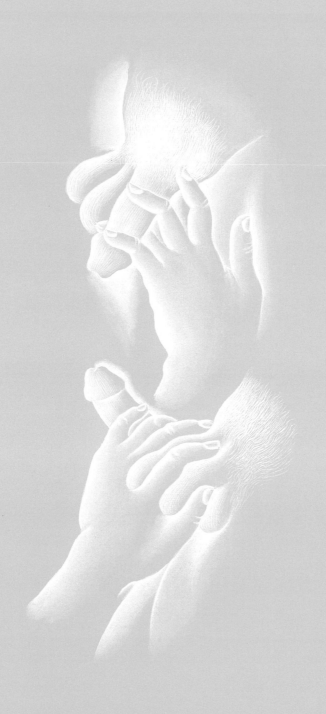

Her hand continued to move slowly, slowly
around and over his pubic hair. A finger sought
the tiny rivulet between the hair and the sex where
the skin was smooth, sought every sensitive part...
slid along under his penis, pressed his balls.

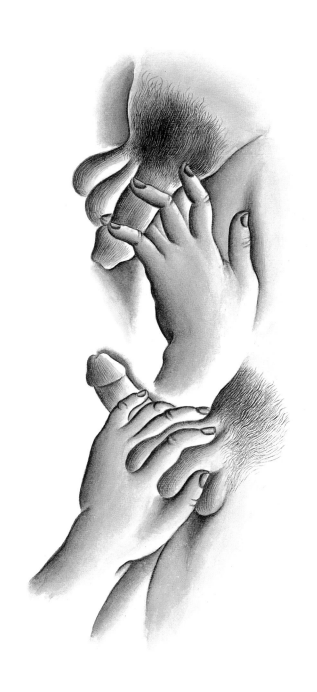

The Basque & Bijou

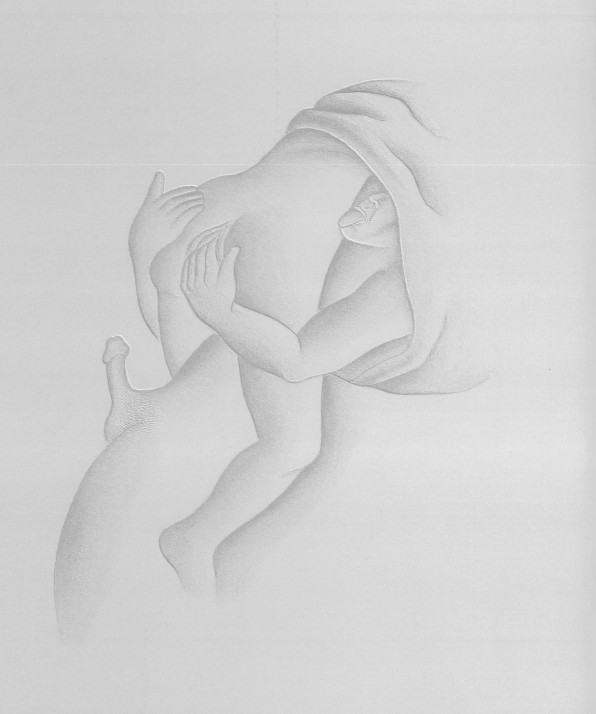

She crouched over his face and held her
dress so that it fell and covered his head.
With his two hands he held her buttocks like
a fruit and passed his tongue between the mounts
over and over again...she saw his erect penis
vibrate with each gasp of pleasure he uttered.

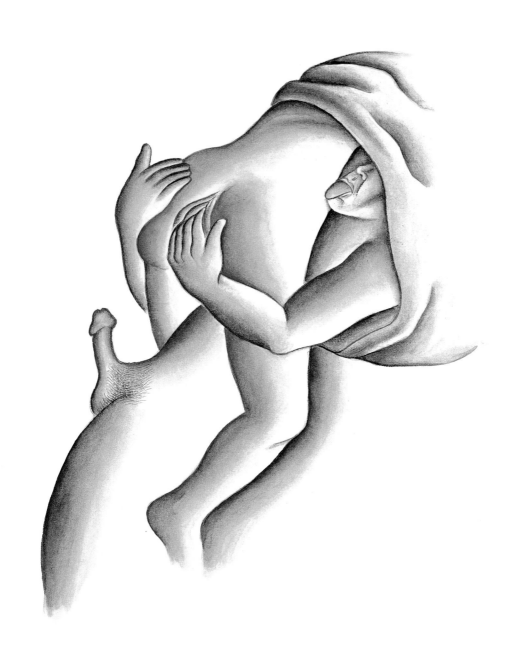

Elena

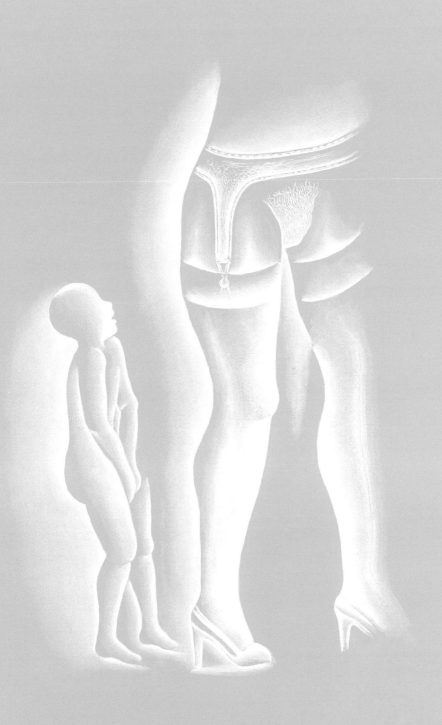

He…watched her powder herself under the arms and
slip the powder puff into her dress, between her breasts.
He saw her emerge from the bath half-covered by her kimono,
her legs naked, and watched her pull on her very long stockings.
She liked her garters to grip her very high, so that the
stockings almost touched her hips....

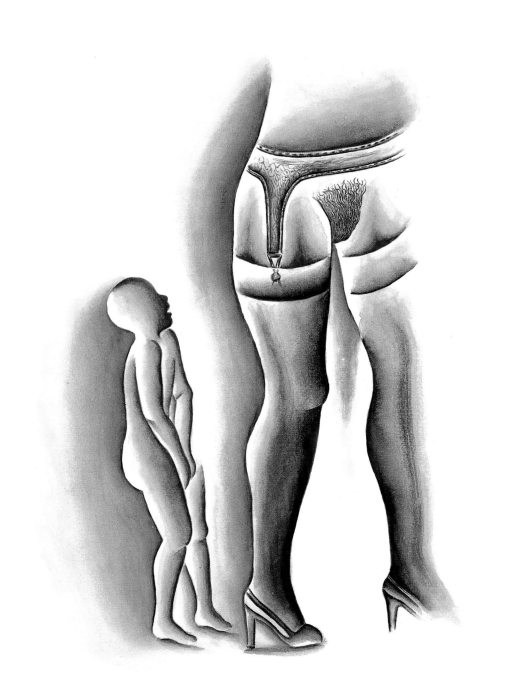

Elena

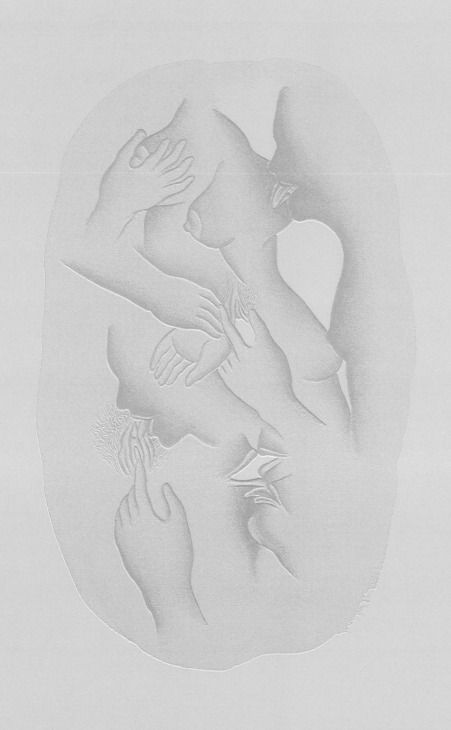

They fell...the three bodies in accord, moving
against each other to feel breast against breast and belly
against belly. They ceased to be three bodies. They became
all mouths and fingers and tongues and senses. Their
mouths sought another mouth, a nipple, a clitoris....
They kissed until the kissing became torture....

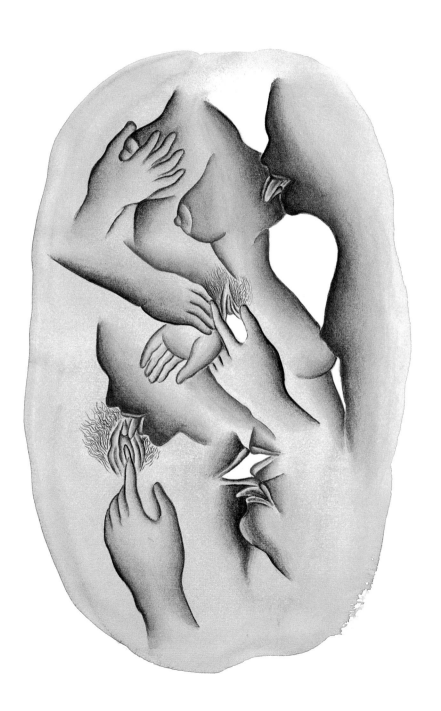

Elena

She saw them caressing each other with their
eyes, and pressing their knees together under the table.
There was such a current of love between them that
she was taken into it. She saw [his] feminine body
dilating, she saw his face open like a flower,
his eyes thirsty, and his lips wet.

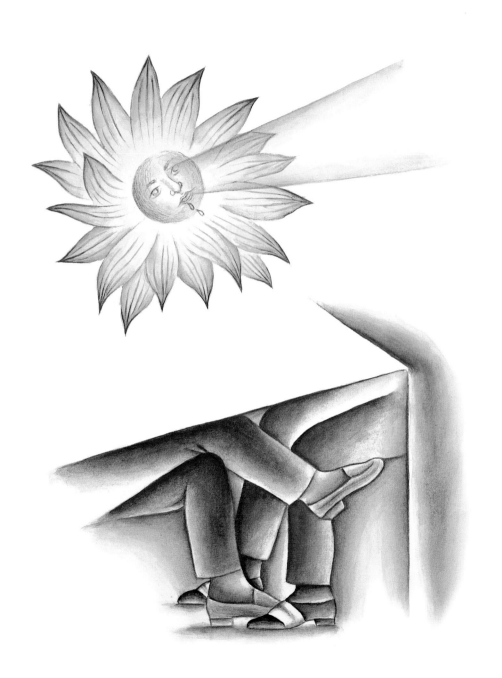

Marianne

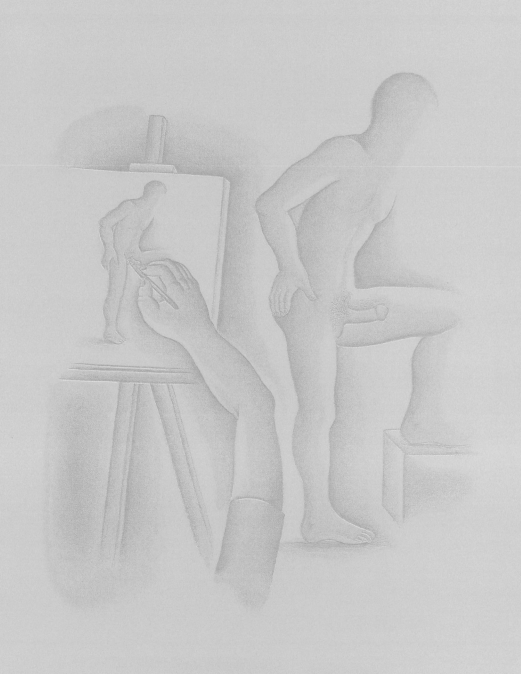

...I thought what a pleasure it would be to draw
the lines of this young man....It was a strange experience.
If I drew his head, neck, arms, all was well. As soon as
my eyes roved over the rest of his body I could see the
effect of it on him. His sex had an almost imperceptible
quiver...I was actually tormented with desire.

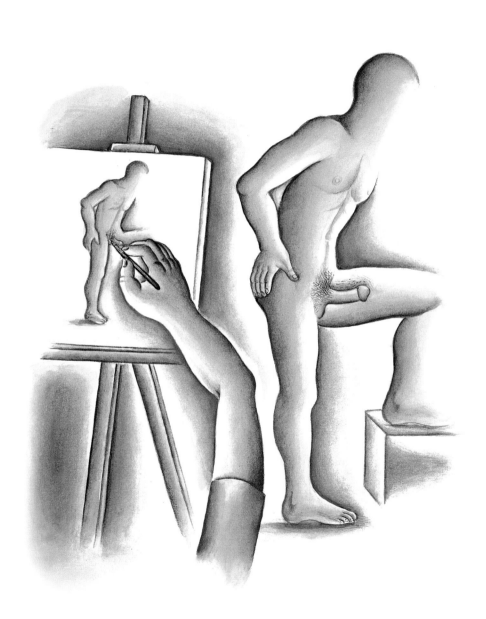

Elena

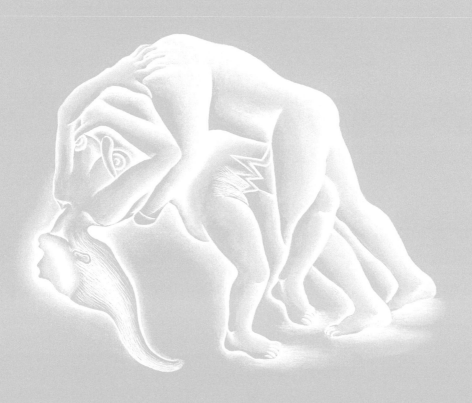

When his fever rose, his breath was like that of some
legendary bull galloping furiously to a delirious goring, a goring
without pain, a goring which lifted her almost bodily from the
bed, raised her sex in the air as if he would thrust right through
her body and tear it, leaving her only…a wound of ecstasy
and pleasure which rent her body like lightning….

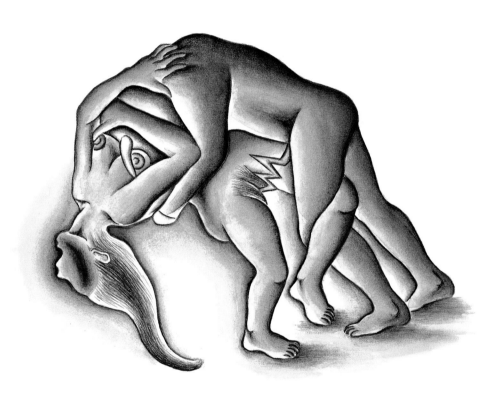

Linda

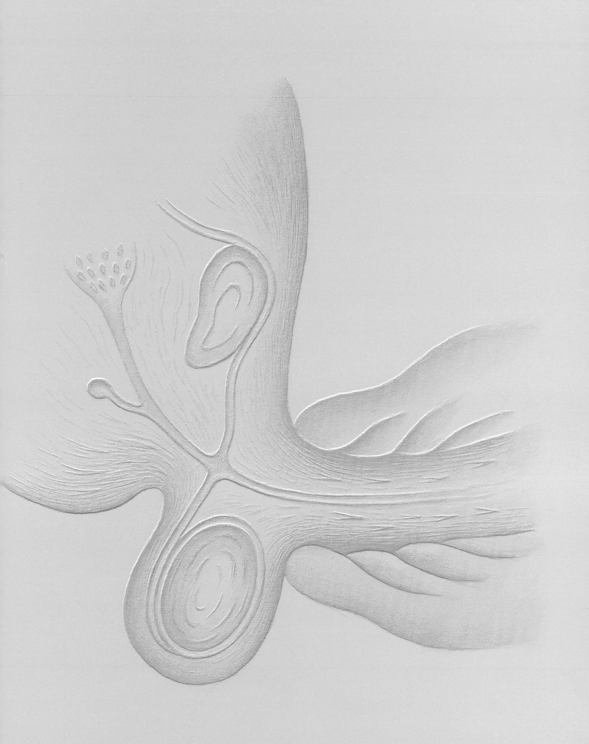

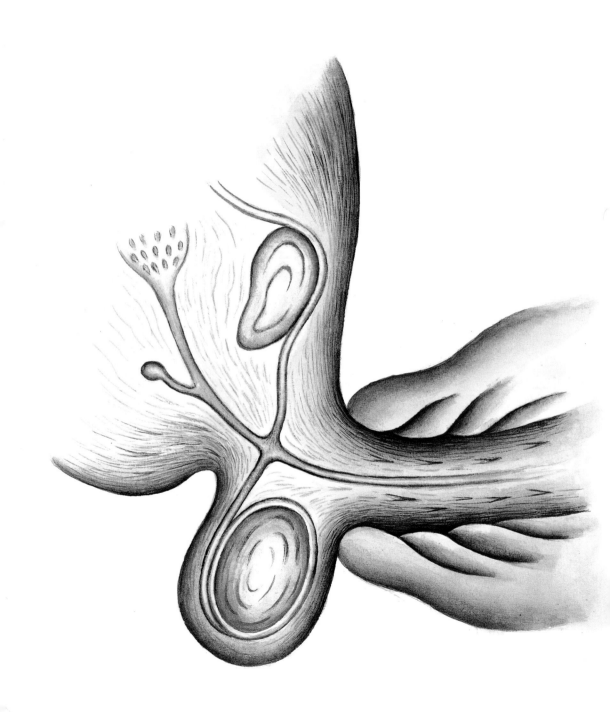

...she felt the orgasm coming and called out to him to increase his thrusts so that they could come TOGETHER....

Elena

Images

watercolor on Fabriano
nine by twelve inches

Giant Hothouse Flower
2001

Little Lips of the Vulva
2001

Seeking the Leaping Tongue
2001

Like Some Marvelous Fruit
2001

Like a Giant Cat
2001

Rising Sexual Hunger
2001

Caressing a Woman
2002

Like a Mouth
2002

Like Sea Anemones
2002

AnimalLike Hands
2002

Suckling at the Nipples
2002

Taking off her Panties
2001

Finding the Tiny Rivulets
2002

Crouching Over Her Face
2002

Watching Her
2003

Three Bodies in Accord
2003

With Their Eyes
2003

Female Gaze
2003

A Delicious Goring
2003

Tongues of Fire
2003

FRAGMENTS FROM THE DELTA OF VENUS

Published in the United States by powerHouse Books,
a division of powerHouse Cultural Entertainment, Inc.
68 Charlton Street, New York, NY 10014–4601
telephone 212 604 9074, fax 212 366 5247
e-mail: judychicago@powerHouseBooks.com
web site: www.powerHouseBooks.com

First edition, 2004

Library of Congress Cataloging-in-Publication Data:

Chicago, Judy, 1939-
 Fragments from the Delta of Venus / artwork by Judy Chicago ; text selections from
Anaïs Nin.-- 1st ed.
 p. cm.
 ISBN 1-57687-182-7
 1. Chicago, Judy, 1939- 2. Erotic painting--20th century. 3. Feminism in art. I. Nin,
Anaïs, 1903-1977. Delta of Venus. Selections. II. Title.

ND1839.C55A4 2003
759.13--dc21

 2003046710

Hardcover ISBN 1-57687-182-7

Separations, printing, and binding by Sfera International, Milan
Photographic reproductions of Judy Chicago's art by Donald Woodman

A complete catalog of powerHouse Books and Limited Editions
is available upon request; please call, write, or visit fragments of our web site.

10 9 8 7 6 5 4 3 2 1

Printed and bound in Italy

Book design by Kiki Bauer